DAVID MILNE

AN INTRODUCTION TO HIS LIFE AND ART

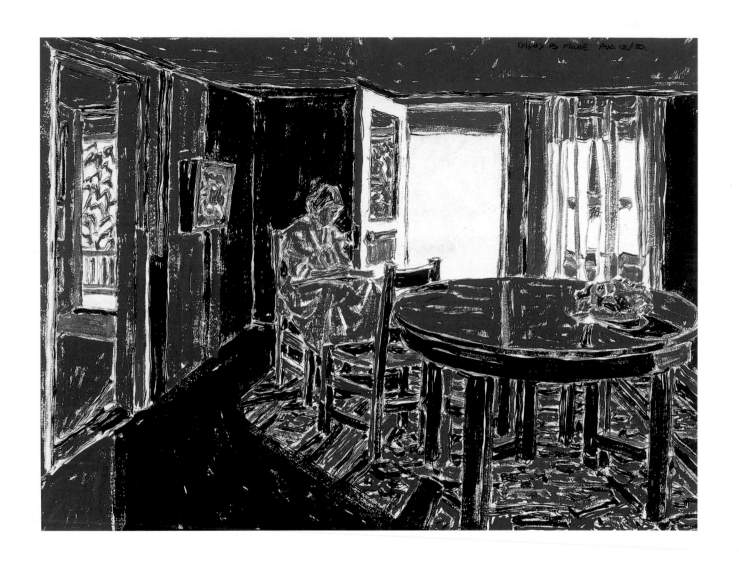

Interior with Table 1920

Watercolour on paper; 38.1 x 50.8 cm. Private Collection.

David Milne

AN INTRODUCTION TO HIS LIFE AND ART

DAVID P. SILCOX

FIREFLY BOOKS

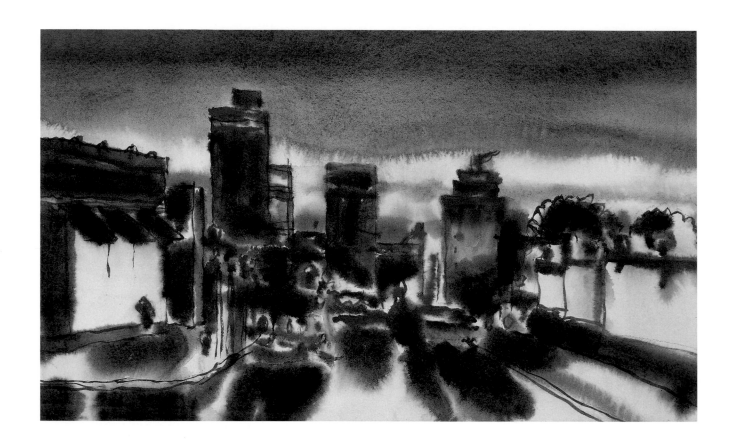

Night 1941

Watercolour on paper; 24.2 x 38.5 cm. Private Collection.

Contents

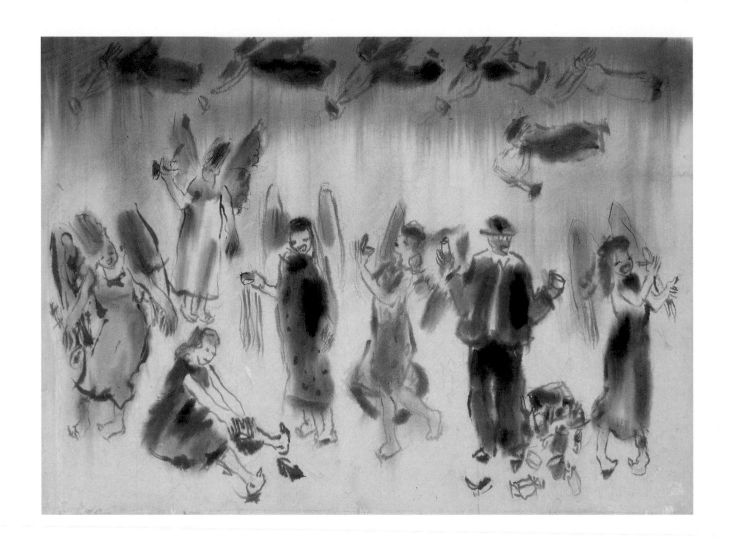

Tempter with Cosmetics V 1952

Watercolour on paper; 55.2 x 75.2 cm. Collection of Agnes Etherington Art Centre, Kingston.
AE 13-079. Gift of the Douglas M. Duncan Collection, 1970. Photo: Larry Ostrom, 1996.

Introduction

David Brown Milne (1882–1953) was of the same generation as the Group of Seven, but he chose a different path as an artist. Instead of studying in Europe, he headed to New York. Instead of adopting aspects of impressionism and art nouveau, he chose to be a modernist. For him art was a purely aesthetic matter, not a form of nationalistic symbolism; art was the result of the intellect and the emotions, not a spiritual construct; art was a private enjoyment, not a public celebration; and the making of art meant following a solitary track, not joining art movements or societies, even if it meant living for many years in relative obscurity. When someone asked Milne if he was a member of the Group of Seven, he replied that he was a member of the Group of One. His tenacity in the face of indifference and poverty was courageous. He thought that true courage was needed to create new conventions in art.

For the first twenty-six years of his adult life, Milne lived, worked and exhibited in the United States. He quickly became known as one of the brash young iconoclasts, and he had five works shown in the controversial Armory Show of 1913.

When he returned to Canada at last in 1929, he was unknown except for his work for the Canadian War Memorials Program in 1918–19. Through the staff of the National Gallery, he became known to

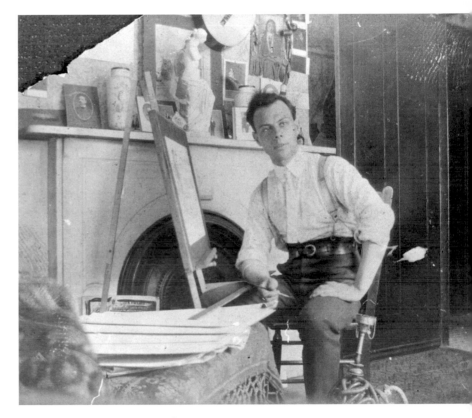

Milne in his New York studio, about 1909

Vincent and Alice Massey, who purchased about three hundred of his paintings in 1934 and then arranged exhibitions of his work. From that point on he became, and remained, a fixture on the national art scene, if not a well-understood one.

Milne was exceptionally intelligent and inventive. At the age of sixty he was still considered by critics and curators as the most innovative artist in the country. His knowledge of art history was both deep and wide. He measured himself and other artists against the great masters: European (chiefly Cézanne and Constable, but the Italians and Dutch too), Asian, Egyptian and American. He was alive to the excitement of children's art because of its freshness and spontaneity, its innocence and verity.

Milne's essays on art, and his letters, diaries and journals, mark him as a great writer too, for all are models of clarity, insight and style. His letters to James Clarke, his friend and patron, are among the significant documents of art in the twentieth century.

Today's painters respect Milne because he had an astonishing technical agility in both oil and watercolour. His colour drypoints, an art form that he invented, are magical. The artist Harold Town referred to him as "the master of absence" for his uncanny ability to leave out everything but the most essential elements in a painting. Milne himself attributed this trait, somewhat slyly, to his Scottish miserliness. Milne's sense of "perfect pitch" in colour, his dazzling but understated virtuosity, and his immense variety are some of the reasons why he is the Canadian painter's painter, and why he is so highly respected by foreign curators and critics.

One: Early Promise and Early Success

David Milne was the tenth and last child of strict Presbyterian, Scottish farming immigrants who had settled east of Lake Huron near Burgoyne, Ontario, just north of Paisley, in 1870. He was born at home, in a simple log cabin, on January 8, 1882, and was his mother's favourite. She kept him at home until he was nearly ten. When he went to school in Paisley (to which they had moved), he proved to be a remarkable student, speeding through all the grades with honours. He went to high school (only the second of his large family to do so) in Walkerton, seventy kilometres away, where he was the most distinguished student in decades. The subject he liked best, because it was mostly drawing, was botany.

After a course at the Walkerton Model School, Milne took up a post as the teacher in a country school near Paisley. He took a correspondence course in art from a New York school, sketched avidly during these years (1902–03), experimented with photography, and then, after having a cover design accepted for *The Canadian Boy,* a short-lived magazine published in Guelph, decided to become an illustrator in New York. He left home in 1903 at the age of twenty-one, travelling by train to Albany and then by boat down the Hudson River to his destiny in New York City.

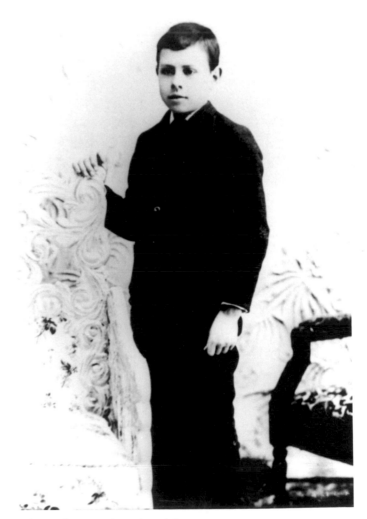

Milne at about age eleven in Paisley

New York City: 1903–1916

The correspondence school Milne had chosen to study at closed abruptly after taking his fees. More fortunately, he then enrolled at the Art Students' League, where he studied for two years, and a third year at nights. The training was essential, the environment was stimulating, and the circumstances of his life were difficult, since he had little money. In 1906 he set up a studio with a fellow artist, Amos Engle, at Fifth Avenue and 42nd Street, where they made a tenuous living painting showcards for shop windows and drawing illustrations for magazines. They took painting holidays (to the Wilkes-Barre area in Pennsylvania and to the Catskills in New York State) and tried to reserve some time for painting each day or week. Soon they were beginning to exhibit in watercolour club shows, and they did so regularly thereafter until about 1920. With his first exhibited work in 1909, Milne also received his first newspaper review: the critic of the Philadelphia *Ledger* dispatched him in one sentence: "The Defiant Maple of David Milne is clever, if bilious."

Among the excitements in New York at the time were the galleries that showed the work of artists who were revolutionizing art conventions in Europe. Not only was the work of the Impressionists to be seen (and Milne was strongly and early impressed by the work of Claude Monet shown at the Durand-Ruel gallery), but Alfred Stieglitz's "291" Gallery also showed Paul Cézanne and Constantine Brancusi for the first time in North America. Milne and his coterie of artist-friends were attuned to and welcomed the great wave of innovation that swept through the art world from Europe at the outset of the twentieth century. These influences, along with those from American impressionism, Milne shaped into a bold modernism that was his own. Critics thought of him as fulfilling the traditions of Georges Seurat and Paul Signac.

As a consequence Milne's work by 1912, such as *Stores and Billboards* (page 13), was about as radical as anything was at that point in North American art history, and it was fitting that he had five works accepted for the great Armory Show of 1913, which brought the new art of Europe to North America with explosive impact. The European painters got most of the attention in the press – Marcel Duchamp, Henri Matisse and Vincent van Gogh in particular getting a constant drubbing from both critics and reporters, and also from the conservative art establishment in the United States. Milne and other local artists were pretty well swamped by the visitors. Milne's five paintings were a larger selection than given most artists by the exhibition's domestic committee. (Edward Hopper, for example, had but one.)

Milne's reputation in New York grew, and he served on the executive of the New York Water Club as well as on the juries for both the American Water Color Society and the Pennsylvania Academy of Fine Arts. His work was handled by the N.E. Montross Gallery, where "The Eight" (later known as the Ashcan School – Robert Henri, William Glackens, George Luks, Maurice Prendergast, Arthur Davies, Ernest Lawson, John Sloan and Everett Shinn) showed their work. He was particularly supported by J. Alden Weir, one of the older generation of American Impressionists, whose work Milne had initially admired. And, after his first press notice, he received fairly extensive and usually positive

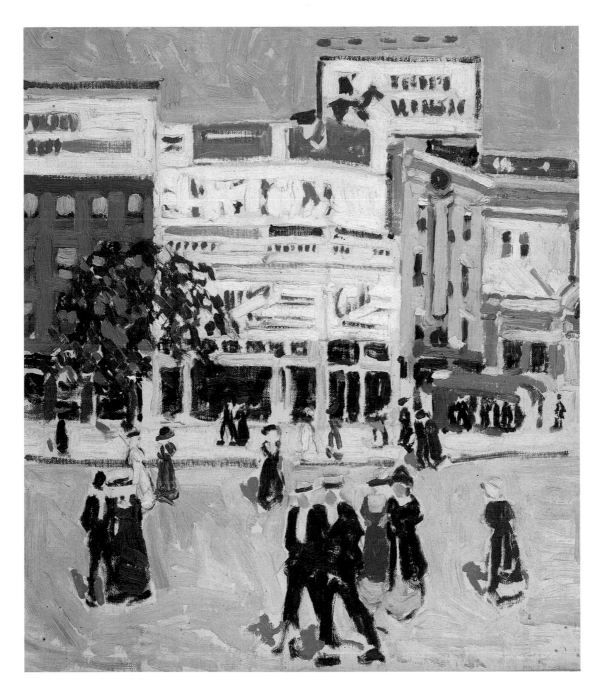

Stores and Billboards C. 1911

Oil on canvas; 50.8 x 45.8 cm Private Collection.

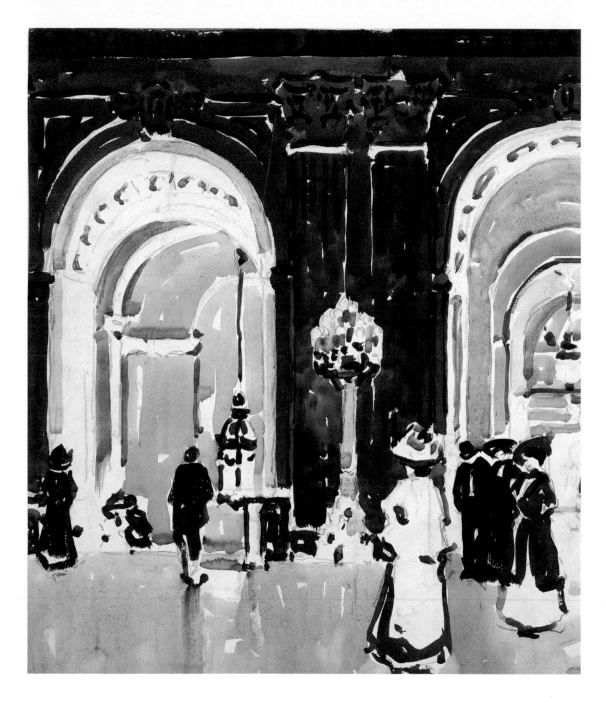

42nd Street Library c. 1911–1913

Watercolour on illustration board; 42.9 x 36.5 cm. Milne Estate.

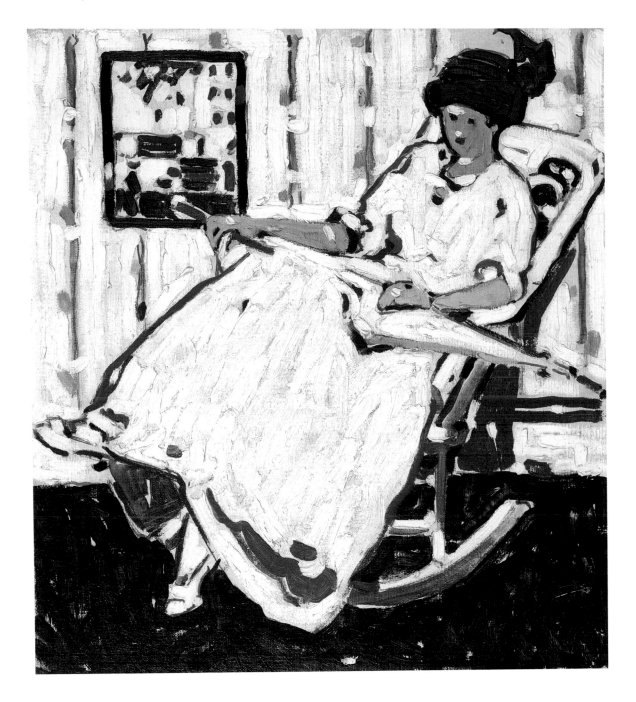

White Rocker C. 1912

Oil on canvas; 50.5 x 45.4 cm. Private Collection.

Lee's Farm 1916

Watercolour on paper; 38.5 x 54.9 cm. Private Collection.

Two: A Solitary Path

BOSTON CORNERS: 1916–1918

Milne moved to this tiny hamlet at the intersection of the New York, Connecticut and Massachusetts state lines in May 1916, where he and Clarke found a little cottage that Milne and Patsy rented from the stationmaster, Joe Lee, for six dollars a month. He described the little cluster of half a dozen houses and a church as "a string of coloured beads, with one end dangling into the cut that held two railways, one road and one stream." One of the "beads" was Joe Lee's farmhouse with barn, caught in Milne's exquisite watercolour, *Lee's Farm* (page 18) – a painting that shows Milne establishing a dramatic opposition between the "washed" upper part of the picture and the simply drawn lower part. The same contrast is found in *Kelly Ore Bed, 1917* (page 27).

Although he carried forward from New York the painting concerns that he had been working on there, the setting gave Milne a fresh approach. Soon he was looking at the magnificent setting that stretched out in front of the Taconic Hills, on whose flank their cottage stood, toward the west across the valley and the rolling country of the Hudson River valley and the Catskills near Saugerties, where the Milnes had holidayed in 1913 and 1914.

Milne at Boston Corners, c. 1916–17

The Clarkes came up to visit regularly, renovations were made to the cottage to prepare it for winter use (Milne was a good handyman), and the Milnes developed an extensive garden that gave them most of the produce they lived on through the winter. Chickens and a duck produced eggs and meat, the nearby trees or the neighbours gave them nuts and fruit for preserves, and milk came from Joe Lee at five cents a quart. Although the couple was frugal and almost self-sufficient, Milne made showcards once a month for the Victor Phonograph Company to earn a little money. Gardening and chores (especially another money-making project of growing celery and onions) occasionally interfered with Milne's painting, but he was able to work intensely.

Milne painted in both oils and watercolours at Boston Corners, and had little difficulty in moving from one to the other. His choice of colours was adventuresome yet austere, since he chose unusual colours and combinations and restricted himself to only three or four at a time – a convention that made things appear to be real, but which were, in fact, purely aesthetic and, in terms of colour, quite abstract. Although his work had changed from the vibrancy and power of the New York work, there was now a poise and steadiness in his paintings – a calm, reflective power that was new. The village itself, the orchards, forests, fields and hills, and the ponds that were scattered throughout the area, all gave Milne an endless profusion of subjects. Perhaps his favourites were the village seen from the high ground of the Taconics and stepped across the valley floor; and the magical reflections of the sequestered ponds – such as Bishop's Pond (see page 26) and Kelly Ore Bed (page 27) – created earlier as charcoal pits used in iron ore smelting.

At Boston Corners Milne established some of his lifelong habits as an artist. His painting days began with a leisurely walk across the fields, when he put his world of worries behind him while he looked for subjects and thought about what he was seeing and waited for his "aesthetic emotion," as he called it, to build up. Then slowly he prepared to paint, anticipated a final treatment but held back until everything was thought through, and finally worked at a feverish pitch and with total concentration to the conclusion. At home in the evening, he would prop up his work and again go through the process of analysis, being critical of his work, seeing where he might improve it, where it might lead the next day.

Milne also started to date his paintings carefully and to write notes about them, urged on by Clarke, to whom Milne began to write descriptive letters. These letters became a sort of journal of Milne's painting thoughts, ideas, activities and plans. Over the next thirty years, Clarke drew out of Milne a stack of letters about his painting that stands as one of the great series of documents of twentieth century art history. Milne proved to be as clever and brilliant a writer as he was a painter.

But just as the momentum of Milne's painting at Boston Corners had gained a wonderful majesty and poise, the call of the war, which had been lurking at the back of his mind for three years, finally was insistent, and Milne enlisted in the Canadian army late in 1917 in New York and left Boston Corners for his basic training in Toronto in early 1918.

Milne in France or Belgium, 1919

THE FIRST WORLD WAR: 1918—1919

After his training in Toronto in March 1918, Milne was transferred to Quebec City, part of the force sent to quell the conscription riots there. His training continued, and through the summer he helped round up deserters in Quebec's eastern townships. Finally in the fall, when it seemed that he might never go overseas, Milne was shipped to England and then quarantined for the usual month at Kinmel Park in Wales, by which time the war was over. As he awaited his return home, Milne accidentally discovered the Canadian War Memorials Program, which had been set up by Lords Beaverbrook and Rothermere to engage Canadian artists to record the activities of Canadian soldiers in the war. Milne was engaged as a war artist to paint places in England where Canadian forces were stationed. After depicting the camp at Kinmel Park (*Kinmel Park Camp: Concert at the 'Y,'* page 22), Milne moved to Ripon in Yorkshire, then to Bramshott in Surrey, and finally to Seaford near the port of Dover. In each place he painted about a dozen pictures, some of which were immediately taken and hung in a large and widely

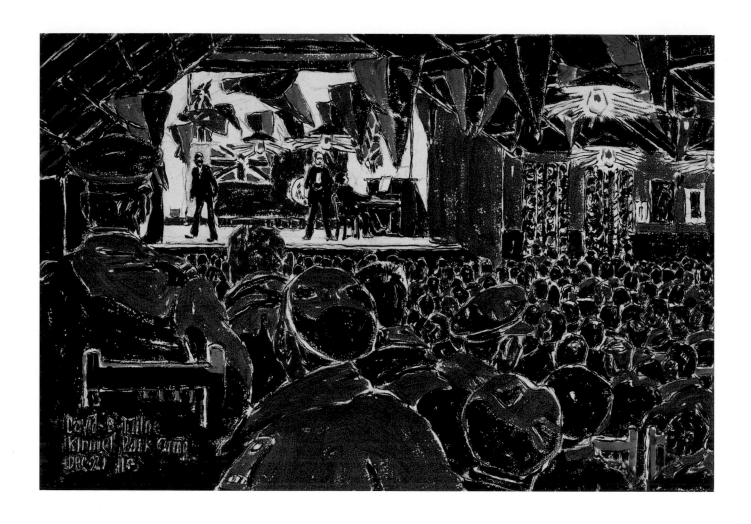

Kinmel Park Camp: Concert at the 'Y' 1918

Watercolour over graphite on wove paper; 29.1 x 42.9 cm. National Gallery of Canada, Ottawa. 8513.
Transfer from the Canadian War Memorials, 1921.

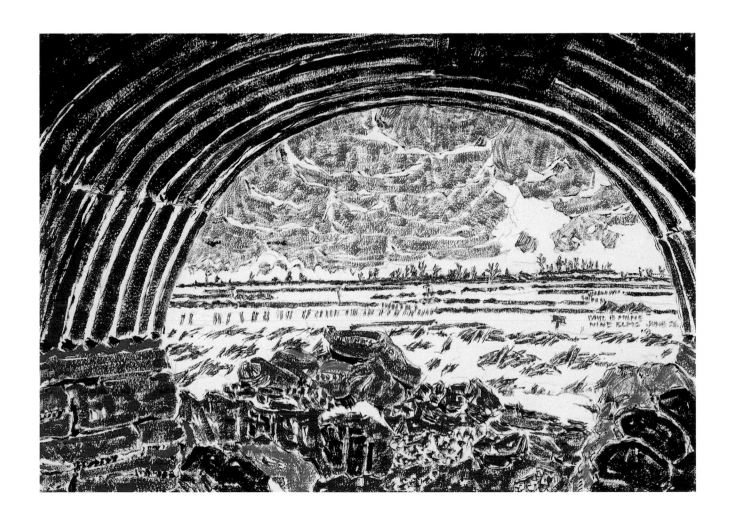

Looking Toward Thélus and Thélus Wood from a Nissen Hut Under the Nine Elms 1919

Watercolour over graphite on wove paper; 35.4 x 50.5 cm. National Gallery of Canada, Ottawa. 8463. Transfer from the Canadian War Memorials, 1921.

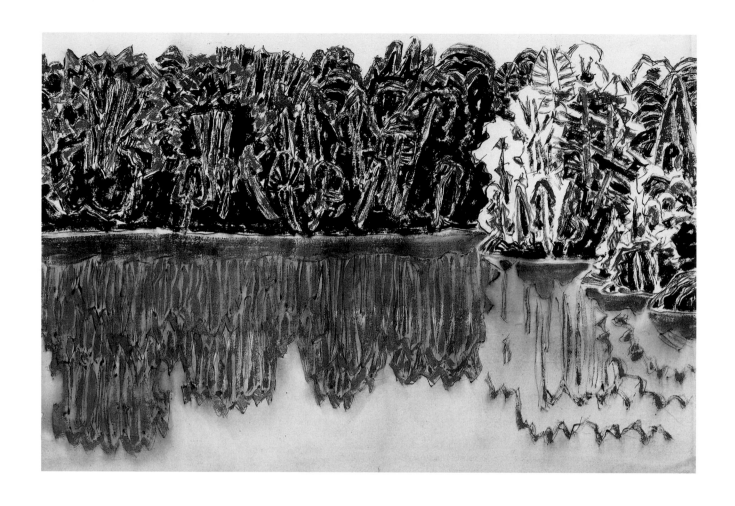

Dark Shore Reflected, Bishop's Pond 1920

Watercolour on paper; 38.8 x 55.6 cm. Private Collection.

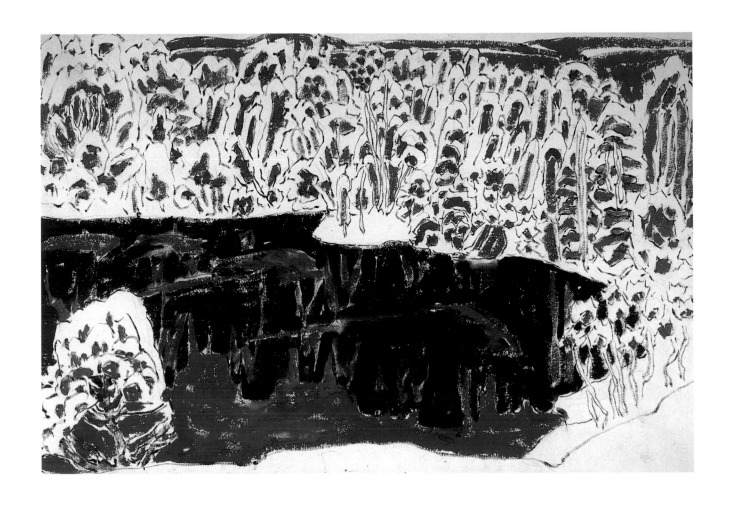

Kelly Ore Bed, 1917 1917

Watercolour on paper; 36.5 x 54.3 cm. Private Collection.

for him, became secondary to line. Lines carried thoughts, whereas colours were arbitrary and elicited emotions. Shapes were drawn in muted outlines: pyramids, fantails, spikes, ribbons and streams were grouped according to aesthetic nuances that are often so subtle they are easily missed – such as a broken line that bisects a picture.

Milne also began to write and type up notes on each painting, numbering, recording his intentions, assessing his performance, noting where he succeeded or failed, what accidental effects might be used again, or where he could go with certain ideas in future works. This sheaf of notes, which explicitly and succinctly describes many of Milne's painting ideas and analyzes the devices he used in painting, is a key document in showing how complicated and sophisticated a painter Milne is.

With the spring of 1920, Milne paused. He turned to gardening and an ambitious effort to grow onions. The fifty bushels he harvested later in the summer were difficult to sell, and his income from them was only $27.50. But as the summer drew to its end, Milne again picked up his brushes and in two months produced another run of great works. Then he paused again.

Alander

In the late fall of 1920, Patsy went to work in New York City when Milne decided to build a simple retreat for himself in a hemlock grove high on the side of Mount Alander, about an hour's hike up the hill behind the cottage. There he wanted to follow Thoreau's philosophy of living with the barest of essentials and to concentrate on making paintings more deliberately and carefully. The easy flow of works in the previous year suddenly seemed too casual to him, and he later destroyed many of them. Much of his time was spent in building a half-barrel–shaped hut and hauling up supplies and materials. In the end he lived there, tenuously, for only a few months. He did only a few paintings, but one like *White, the Waterfall* (page 29), arrived at after many days of intense work, impelled Milne into new possibilities.

Dart's Lake

Economic necessity finally drove Milne out of seclusion in the spring of 1921. Patsy got work as a bookkeeper at a summer resort on Dart's Lake, near Big Moose Lake in the western Adirondacks, and she arranged for Milne to be hired as a part-time handyman, his afternoons free to paint. The summer saw further working out of the line-heavy, drybrush watercolour idea, which had its genesis in the war paintings of two years earlier. Milne's use of a rough, apparently monotone line to define both spaces and objects, what he called his "open and shut" motif, was pushed along to its limit here and over the next few years. The culmination at Dart's Lake was *Across the Lake I* (page 30), in which Milne had the remarkable courage to leave the lower half of the picture space empty.

Mount Riga, Big Moose

After another winter staying at their friend James Clarke's house at Mount Riga, near Boston Corners, Milne and Patsy returned to the Adirondacks to run a tea house concession at the Glenmore Hotel on Big Moose Lake. The painting during these years (1921–23) was pushed forward, but not with the

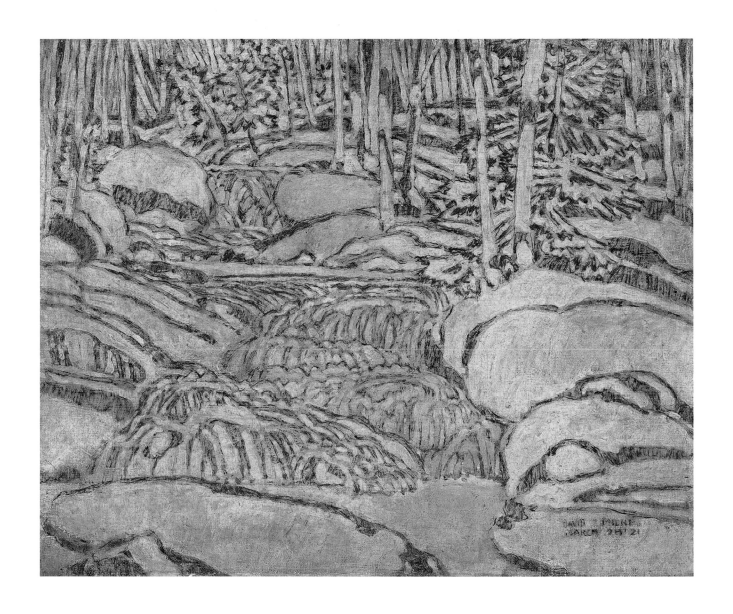

White, the Waterfall (The White Waterfall) 1921

Oil on canvas; 45.8 x 56.3 cm. National Gallery of Canada, Ottawa. 7156. Purchased 1959.

Across the Lake I 1921

Watercolour over graphite on wove paper; 39.6 x 56.9 cm. National Gallery of Canada, Ottawa. 16427.
Gift of the Douglas M. Duncan Collection, 1970.

Kaye's Fence 1923

Oil on canvas; 30.5 x 40.7 cm. Private Collection.

for twelve years. His painting sessions were sporadic, and his yearly production plummeted. When he did paint, however, his work was as strong as ever, sparkling with vitality, and, in some respects, was as wonderful as it had been in the years before, as may be seen in *Early Morning* (page 37).

In the winters during these years (1924–29) the Milnes tended the tea house at the foot of the Lake Placid ski jump, 150 kilometres to the east of Big Moose, preparing meals and snacks for the members of the Lake Placid Ski Club. This arrangement gave Milne time to paint, and although his initial reaction to Lake Placid was somewhat sour, he became more enthusiastic as he learned to ski. He came to admire the landscape, one so different from the western Adirondacks or the country around Boston Corners, as may be seen in *North Elba I* (page 35). The mountains of the area were impressive, and he also was drawn to the farm of John Brown, the abolitionist, which was close by. Milne's work at Lake Placid managed to retrieve most of what he lost during the summers at Big Moose, although it is the paintings of Big Moose, such as *Outlet of the Pond, Morning* (page 36), that seem to hold more of Milne's affection. The most outstanding work of these years is the series of *Painting Place* paintings (see *Painting Place III*, page 38), which began as a drawing done on top of Billy's Bald Spot, up the hill behind the Milne cottage, overlooking Big Moose Lake.

This subject was tackled several times, finally finished in Canada in 1930, and also used in Milne's best-known drypoint. The subject sums up Milne's achievement at mid-career, with the artist's materials in the foreground, the framing device of the stump and trees, and the view arching out across the lake to the distant shore.

Lake Placid was the place where Milne finally began to make the coloured drypoint etchings he had been thinking about since 1922, when he had tried to make them using primitive plates and a needle lashed to two sticks; for a printing press he borrowed his neighbour's washing machine wringer. Clarke bought him a professional etching press in 1927. Milne, after some experimentation and after refining some of the techniques required (he had made etchings in New York in 1909–11), became quite proficient in the medium. His idea of coloured drypoints, a different plate for each colour, printed one over the other, was totally original, since no one had made such works before. Few have made them since, and none with Milne's magical skill and vision.

At last Milne sold his cottage at the end of 1928, to Patsy's dismay. He left in the spring of 1929 and travelled, via Ottawa, to Temagami, Ontario. Patsy stayed at Lake Placid. The mortgage on the cottage, which Clarke and Milne assumed, managed to pay a trickle of money that sustained the Milnes over the next decade and more, and helped them through the Depression. After Milne left Lake Placid, following a trip with Clarke up Mount Marcy in the spring of 1929 – the last time he would see his friend – he lived in Canada for the rest of his life. He was halfway through his brilliant career and he was forty-seven years old.

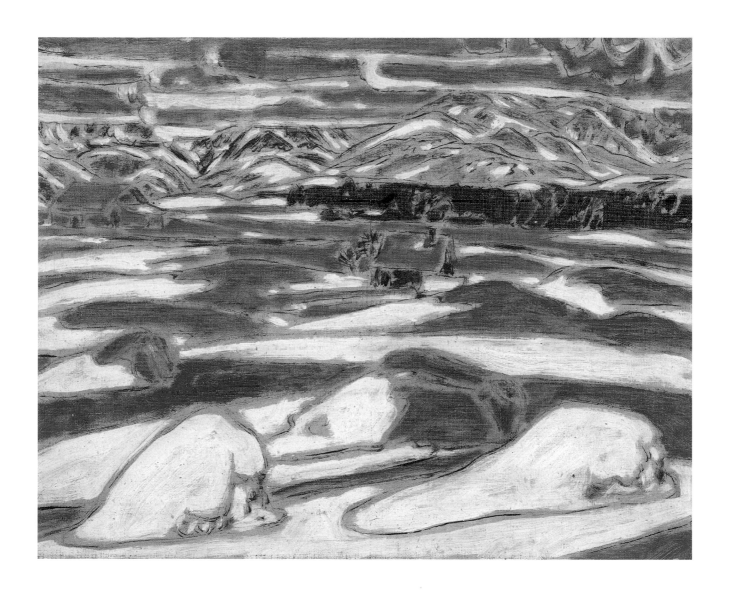

North Elba 1 1926

Oil on canvas; 40.7 x 50.8 cm. Private Collection.

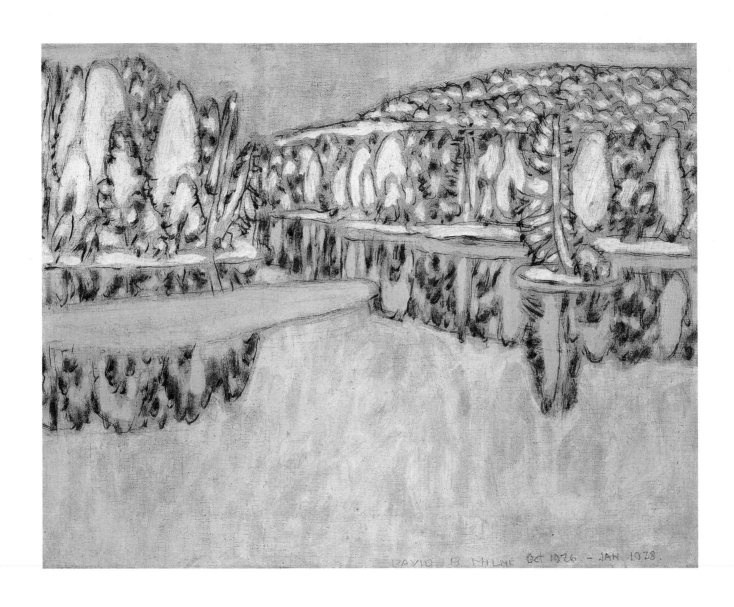

Outlet of the Pond, Morning (Outlet of the Pond III) 1928

1928. Oil on canvas; 41.0 x 51.1 cm. Private Collection.

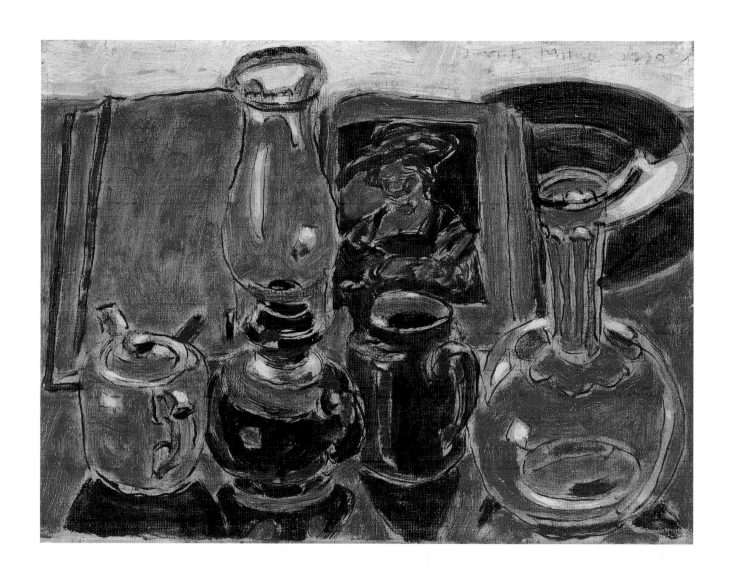

Early Morning 1928

Oil on canvas; 30.5 x 40.7 cm. Private Collection.

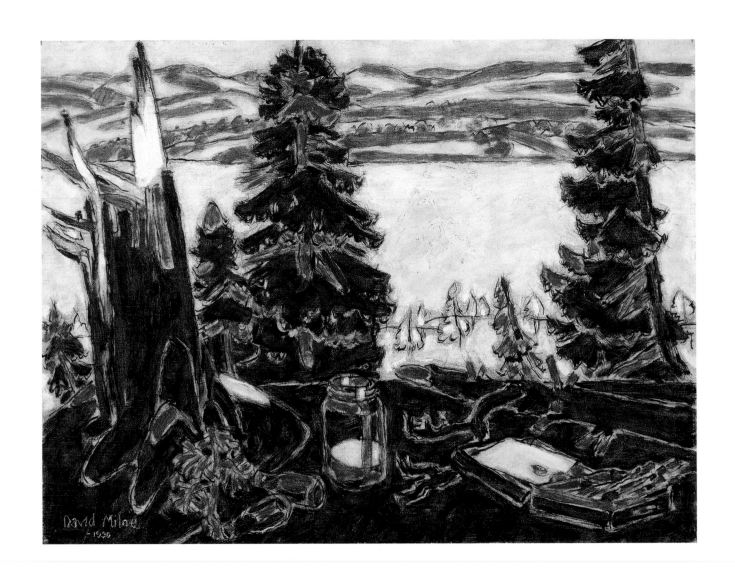

Painting Place III 1930

Oil on canvas; 51.3 x 66.4 cm. National Gallery of Canada, Ottawa. 15520. Vincent Massey Bequest, 1968.

Three: The Great Depression: Years of Productivity

TEMAGAMI, WESTON, PALGRAVE: 1929–1933

Milne arrived alone at the small railway village of Temagami in early May 1929, when the snow was still clinging to sheltered areas of the bush. He rented a canoe and camped on an island not far down the lake from the village, and began the difficult process of reclaiming his life as a professional painter. His work as an artist had been disrupted by cottage building, tea house operations and sign-making. Moreover, the Milne marriage was in difficulty. Milne moved back to Canada without Patsy, who had taken a job at Lake Placid for the summer – their fourth lengthy separation in ten years.

Milne spent the summer committed to the act of painting. He worked only in oils, had no visitors, spent little time doing anything else except painting or thinking about it, and managed to complete nearly forty works that indicate a change in direction, based on his work at Big Moose and Lake Placid. His subjects were the village of Temagami, an abandoned mine shaft, flowers in a prospector's deserted shack (such as *Flowers and Easel,* page 43) and general landscapes. He wrote several long letters to James Clarke, including some beautiful letters about painting, and thought a good deal about how he was going to tackle his painting, now that he was determined to refocus his efforts on this aspect of his life.

His production for the summer, while not high, provided an impetus and set a standard for the winter ahead, even though Milne wrote later that these works were "all failures," and that "they came to nothing." But in fact his summer was a resounding success, since he had indeed re-established his life as a painter. He had produced close to forty works, really all quite good and some outstanding; he had concentrated on painting and made it the centre of his life again; and he had, in a sense, reconsecrated himself to the muse of art.

When the fall set in, Milne moved to Weston, then a village near Toronto, where Patsy reluctantly joined him. Milne's studio was in the old Longstaff Pump Works, which then was at the corner of what is now Weston Road and Coulter Avenue in Toronto. They lived on St. Albans Avenue, a small residential street, and made no friends. Milne tried to enter the art world by visiting the Art Gallery of Toronto and writing to Harry McCurry at the National Gallery of Canada. Patsy was quite unhappy.

Milne spent the winter refining some of the works done in Temagami; repainting some from Big Moose, such as *Painting Place III* (page 38); and doing a few paintings of locations nearby. Most

of his time was devoted to making drypoints. At Weston, Milne finished the first drypoint based on *Painting Place* (soon to be published as *Hilltop* and now also known as *Painting Place*) and completed *Across the Lake, Stream in the Woods, Waterfall* and *Haystack*. All were Adirondack subjects.

In the early spring of 1930 Milne and Patsy moved to a small, unfurnished house behind the Queen's Hotel in the tiny village of Palgrave in the Caledon hills northwest of Toronto. The move was for economic reasons – cheaper rent, rural surroundings, and an opportunity to plant a garden and be more self-sufficient. With the Depression setting in, being closer to Toronto did not seem to hold any advantages. "Artists stand depressions quite well," Milne wrote, "since depressions look so much like their regular brand of prosperity."

The three years in Palgrave were splendid for Milne's painting, although it was deadly for him and Patsy. He produced over two hundred oil paintings of exceptional quality, complexity and variety. He and Patsy signed a legal separation in 1933 and did not live together again. Poverty and the Depression both added to the difficulty of their relationship. The new owners of the Big Moose cottage, moreover, defaulted on their mortgage payments; although they paid interest from time to time, money was very short. Milne's first priority, doubtless to Patsy's distress, was sufficient painting supplies. He also devoted a lot of his time to writing, prodded by Clarke to turn his thoughts about painting into a book. He wrote lengthy letters to Clarke (some of them up to fifty pages), to Maulsby Kimball in Buffalo (who had purchased some work at an exhibition at Cornell University in 1922), and to others,

outlining his theories, practices and observations. To Harry McCurry, his contact at the National Gallery, he sent a detailed criticism of exhibitions of the Group of Seven he had seen in Toronto in 1930 and late in 1931, rating each member's virtues and vices with telling and shrewd observations

Milne's first major task at Palgrave was a commission obtained by James Clarke from Elmer Adler, editor of a classy periodical for bookmen, *Colophon,* to produce two thousand original prints to be bound into the fourth issue. Milne chose the *Painting Place* subject, in black and green, which he had already worked out. Such a large production in this medium meant resurfacing the plates in steel a dozen times or more and working steadily for weeks. Milne missed the deadline. Part of the delay was in getting the works past United States customs; and the subterfuge suggested by Adler of sending small shipments to friends in upstate New York, Ohio, Illinois and elsewhere only created further confusion. Then the decision was made to publish three thousand copies of the fifth issue. So Milne eventually produced three thousand copies of his drypoint.

Apart from the drypoints to which he turned his hand in 1930 and 1931 to produce *Barns, Lines of Earth, Queen's Hotel, Yard of the Queen's Hotel* and *Blind Road* (and a few others), several Adirondack subjects (*White, the Waterfall; Outlet of the Pond;* and *Lake Placid*), and *Prospect Shaft* (a Temagami subject), Milne concentrated on oil painting. Among them was a huge (for him) painting, 56.2 x 71.9 cm (22 x 28 inches), called *Window* (page 47), a view from the rear window of their house looking across the roofs of the village. Two years later this painting was purchased in Ottawa on the recommendation of

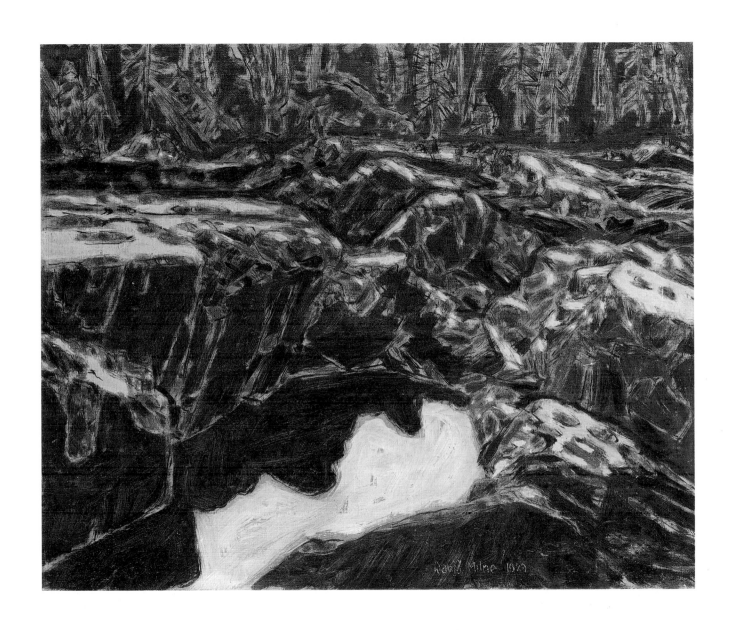

Riches, the Flooded Shaft 1929

Oil on canvas; 51.5 x 61.6 cm. Private Collection.

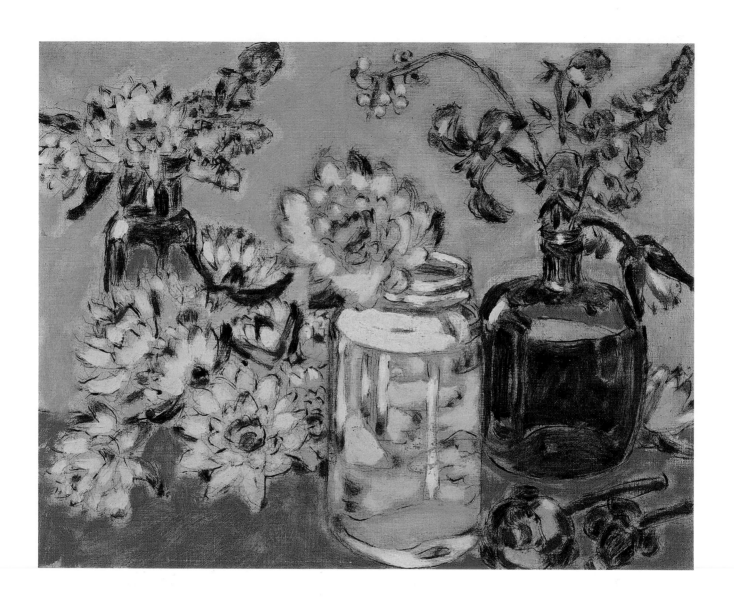

Waterlilies 1929

Oil on canvas; 41.0 x 51.1 cm. Art Gallery of Greater Victoria.

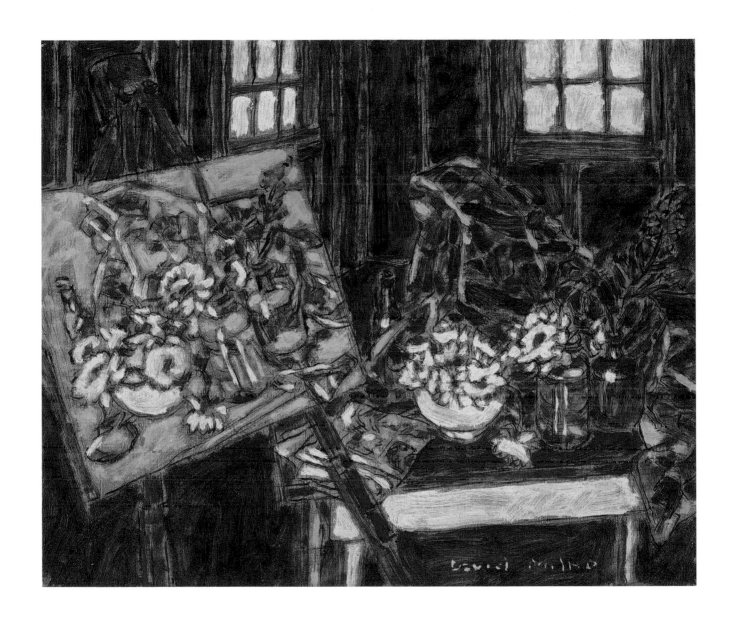

Flowers and Easel 1929

Oil on canvas; 51.1 x 61.6 cm. Victoria College, University of Toronto.

the National Gallery, probably Eric Brown or Harry McCurry, by Vincent and Alice Massey, leading art patrons, for $175. It was their first acquisition of a Milne.

Looking west from the upper front window of his studio, Milne had a clear view of Ollie Matson's house across the street. This subject was painted often and lovingly. From his back window Milne looked into the Queen's Hotel's yard. In the country around were the farms, which inspired Milne to create a work like *Barns* (page 5). In all these paintings Milne was developing a system of painting that saw him setting in values in place of colours: white, gray and black. These were the bones, or skeleton, of a painting. Colours, used sparingly and few of them, were for accents only. Transpositions were possible: clouds could be blue and sky white, rather than the other way around, yet the viewer would probably read the painting without noticing, since the shapes, not the colours, were what they read.

Although Milne painted mostly landscapes during this period, the occasional still life emerged. *Framed Etching* (page 46) of 1931, with the framed drypoint of *Waterfall* sitting amid a profusion of trilliums, is the most striking of these. It uses the device of the "dazzle spot," the large white reflection in the glass of the etching, which Milne

had discovered inadvertently in 1916 and used sporadically thereafter. The "dazzle spot," as Milne described it, gave the viewer a quick, sharp entry into a painting, after which the eye slowed and then travelled around the detailed parts of the painting.

The most astonishing of Milne's many achievements during this three-year period were, first of all, the fact that he continued to work at a high pitch of energy, despite the rigours imposed by the Depression and his sorry financial state. Initially the Milnes had no furniture, their diet was parsimonious in the extreme, Milne himself had but one pair of pants and one shirt (Clarke sent him a coat), and he had to barter his labour for the winter's wood. Most miraculous of all, he painted the nondescript hamlet of Palgrave and its environs as if the place were heaven itself. *Queen's Hotel, Palgrave* (page 45) is one example of this transformation of plainness to an elevated glory through the alchemy of art, and perhaps the most sublime of Milne's portraits of a small rural town. The hotel basks in the sun of a summer's day in the Depression, and the scene is a masterpiece of serenity and precision in five colours, exquisitely articulated from roof to roof, gable to gable, awning to awning, and held in perfect equipoise against the expanse of a sultry sky.

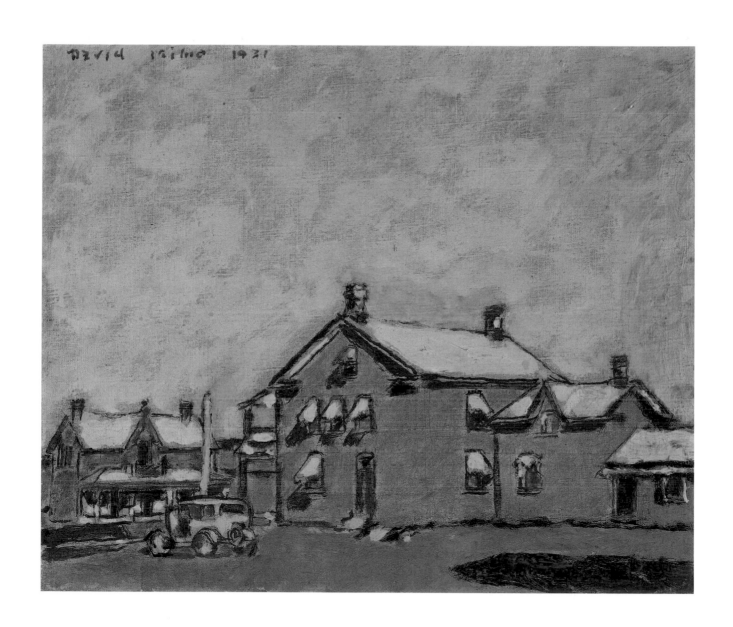

Queen's Hotel, Palgrave 1931

Oil on canvas; 51.1 x 61.3 cm. National Gallery of Canada, Ottawa. 15526. Vincent Massey Bequest, 1968.

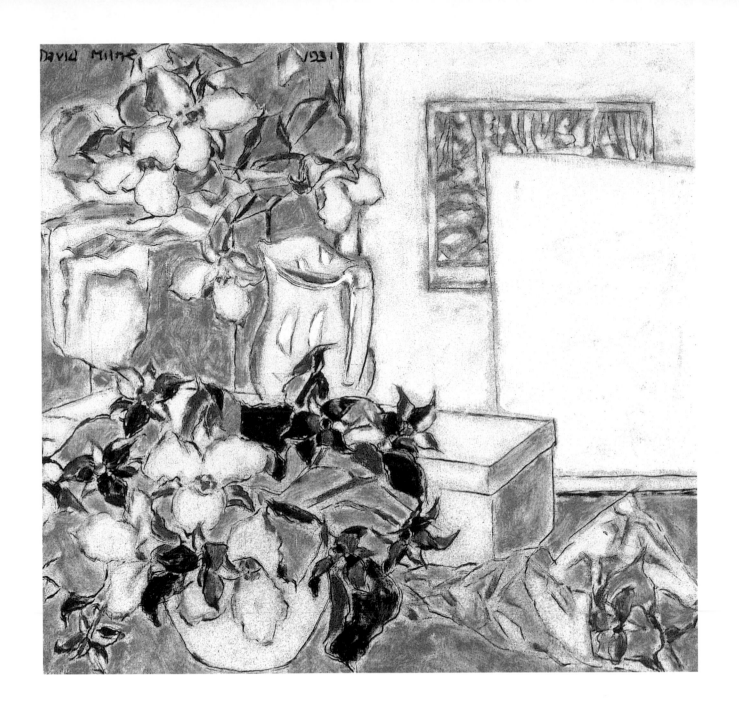

Framed Etching (Lilies from the Bush) 1931

Oil on canvas; 66.1 x 71.1 cm. Government of Canada, Department of Foreign Affairs, Ottawa. 985.

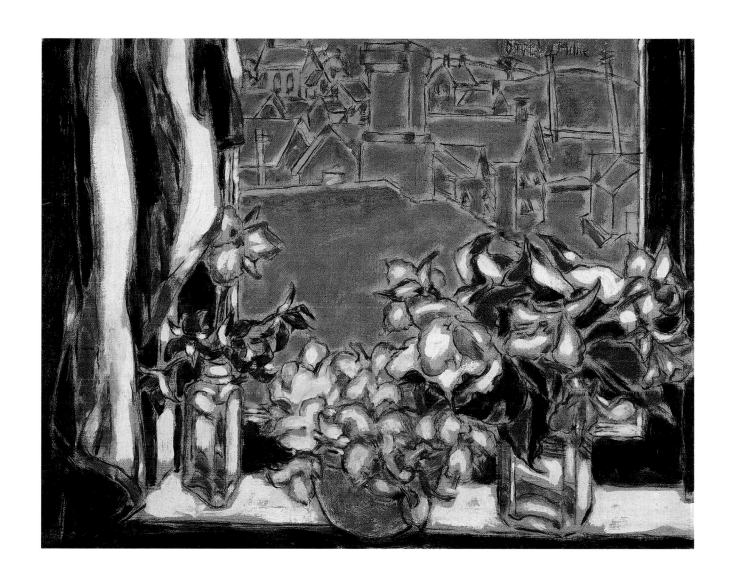

Window 1930

Oil on canvas; 56.2 x 71.9 cm. National Gallery of Canada, Ottawa. 15516.
Vincent Massey Bequest, 1968.

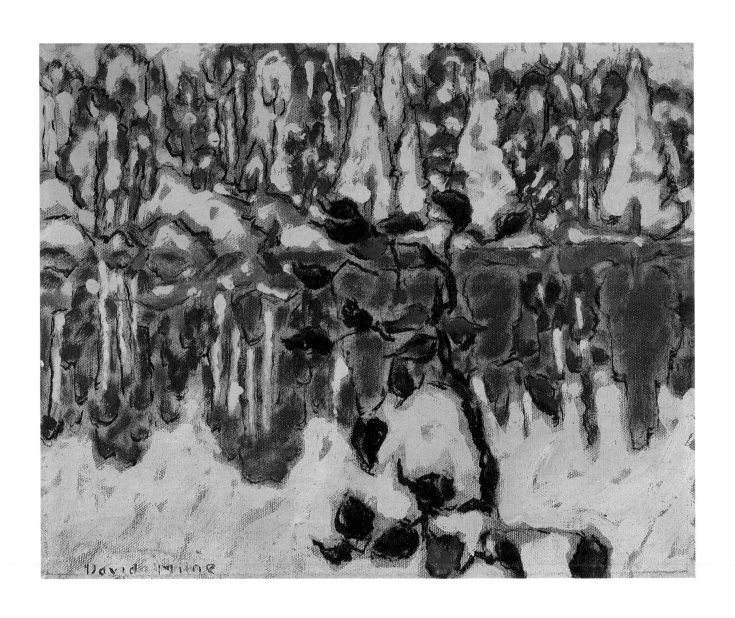

Alder Branch 1933

Oil on canvas; 45.8 x 56.5 cm. Private Collection.

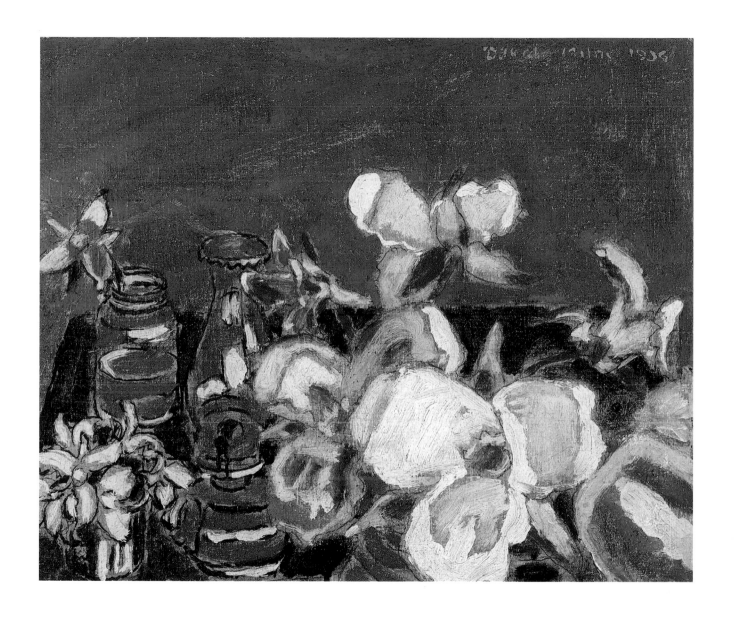

Trilliums and Trilliums 1936

Oil on canvas; 48.0 x 58.2 cm. Private Collection.

dollars each. In the end, the Masseys bought about three hundred paintings (his total production from Temagami, Weston and Palgrave, with a few from the Adirondacks thrown in). The Masseys, contrary to Milne's wishes, almost immediately began to resell some of their purchase through the Mellors Galleries in Toronto and promised Milne a share of the profits once their initial outlay of $1,500 had been recouped. Because of numerous expenses and the dealer's fat commission, a "profit" was never achieved, although sales were brisk. The Masseys also "purchased" Milne's production from 1935 and 1936 for even less per painting, although the understanding about these later transactions, complicated by a secret agreement with Mellors Galleries, the forerunner of the Laing Gallery, led to an acrimonious explosion in 1938 when the relationship was abruptly ended. Some paintings were returned to Milne, but there was very little money. The Masseys came out well ahead financially, and still had nearly 350 paintings with which to decorate their house. They sold most of those works in 1958 for a substantial profit (some $30,000-plus, as against their initial outlay of $1,500), without giving any money to Milne's estate or his then needy dependants.

The patronage of the Masseys, despite their ultimate stinginess, was beneficial to Milne in many ways that he readily acknowledged. First, the exhibitions the Masseys arranged at Mellors Galleries in Toronto, in which only the Masseys and Mellors made money, brought Milne a large measure of attention and subsequent sales. One of the critics of the first exhibition in 1934 was Alan Jarvis (1915–72), then a student at the University of Toronto and later a Rhodes Scholar and director of the National Gallery of Canada. He became an avid Milne supporter and brought his work to the attention of many people, the most important of whom was Douglas Duncan (1902–68), a wealthy dilettante and collector who shortly became the *de facto* director of the Picture Loan Society in Toronto and Milne's agent and dealer for the rest of both their lives.

Throughout this period, with its unique act of patronage, Milne's painting continued with considerable success and vitality. His little portrait of his cabin on January 1, 1935, *Winter Sky* (page 48), celebrated, perhaps, his success with the Masseys, the New Year and the fact that his painting was progressing reasonably well. With a measure of prosperity returning, and more stability in his life, flowers again became a constant theme in Milne's work. Paintings like *Trilliums and Trilliums* (page 51) and *Alder Branch* (page 50) show how ebullient Milne could be when the subject inspired him.

Other profound changes occurred in Milne's life. His work was suddenly set off in a new direction by two things: his return to watercolour in 1937; and, in the same year, two works inspired directly by children's paintings, which led to various fantasy pictures, often with religious subjects, over the next fifteen years. From the moment Milne returned to watercolours, his production of oil paintings dropped precipitously; it was practically nonexistent in his later work. Another of the paintings he did at Six Mile Lake, just before he left, was *Cabin at Night II* (page 53) – a black and red watercolour that shows Milne's jacket hanging over his bed, his Aladdin lamp (which acts as a "dazzle spot") and his cabin.

In 1938, in the midst of all these changes, Milne met and fell in love with Kathleen Pavey, a nurse half his

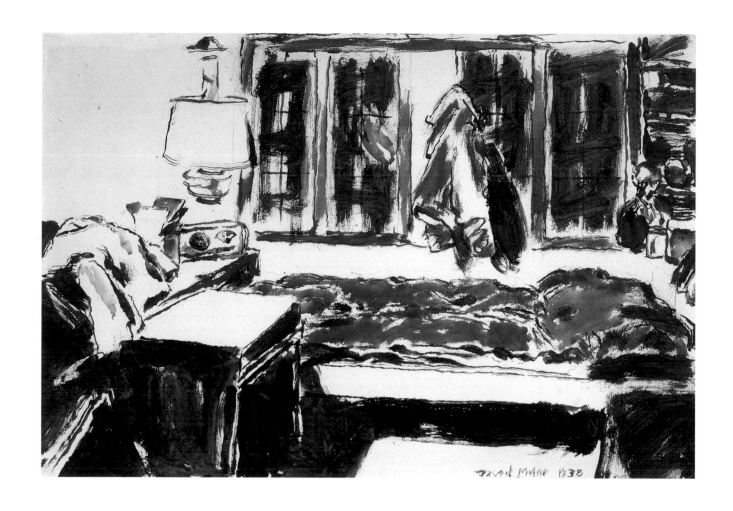

Cabin at Night II 1938

Watercolour on paper; 42.0 x 61.6 cm. Private Collection.

age. She was camping in the area and had been introduced to Milne by Carsen and Kay Mark, with whom she shared an apartment in Toronto. (Kay was a school friend of Kathleen's. Carsen was a brilliant graduate student in physics at the University of Toronto. He became a friend of Milne after they met on the Severn River and, unable to find a position in Canada, moved in about 1942 to Los Alamos, New Mexico, where he became the head of theoretical nuclear physics — and a mentor and guide to a generation of young American physicists.) After visiting Kathleen in Toronto and Muskoka over that winter, Milne closed his little cabin and moved to Toronto in the spring of 1939.

TORONTO, UXBRIDGE, BAPTISTE LAKE: 1939–1953

Milne's Toronto sojourn was both intense and short. He was inspired to work, both by the changed circumstances of his life and by the novel subjects he discovered as he trekked about the city, explored its ravines, and tramped along its shoreline. He depicted the Parliament buildings at Queen's Park, churches, breweries, little houses and apartment buildings here and there, and other urban sites. Indeed, the subjects he sketched here, even after he moved on to Uxbridge and Baptiste Lake, provided him with the basis of works for the rest of his life. Toronto was thereafter the centre he visited frequently.

Although Milne had previously worried about a subject and done it in several different guises, he now became almost terrier-like in worrying a subject into many different versions. One series that hung on for several years was *Stars over Bay Street*, a painting of Eaton's College Street store seen from the north looking down Bay Street (see *Night*, page 6). This subject was done many times in a wide variety of versions.

After little more than a year living at 1 Homewood Avenue, the Milnes (Kathleen had taken his name, although David was not divorced from Patsy) moved to Uxbridge, Ontario, a small town northeast of Toronto where they could live less expensively and, more importantly, less obviously. Kathleen was expecting a child, and in those days the social stigma of out-of-wedlock arrangements was certainly cause for scandal. Just as compelling, perhaps, was that Patsy was attempting to effect a reconciliation. In any case, David Milne Junior was born on May 4, 1941, in Toronto, and Milne suddenly had family responsibilities.

The new Milne family moved into a house at Cedar and Brock streets and, just a short distance away on Brock Street, Milne found a studio space above Gray's Bakery in the centre of town, overlooking the main street.

All Milne's correspondence and financial matters were funnelled through Duncan at the Picture Loan Society in Toronto, so no one really knew where he was living. The reason was that he did not want a confrontation with Patsy, who had heard of Milne's liaison. She imagined the worst about Kathleen. Milne ignored her entreaties and pretty much all else: he settled in to work and for the next seven years he painted steadily, despite the war and the privations it imposed. Selling paintings was difficult, and good-quality painting materials were hard to find. These years produced a stream of landscapes, floral still lifes and fantasy pictures, quite a number of them painted many times before a definitive version was deemed to have been achieved.

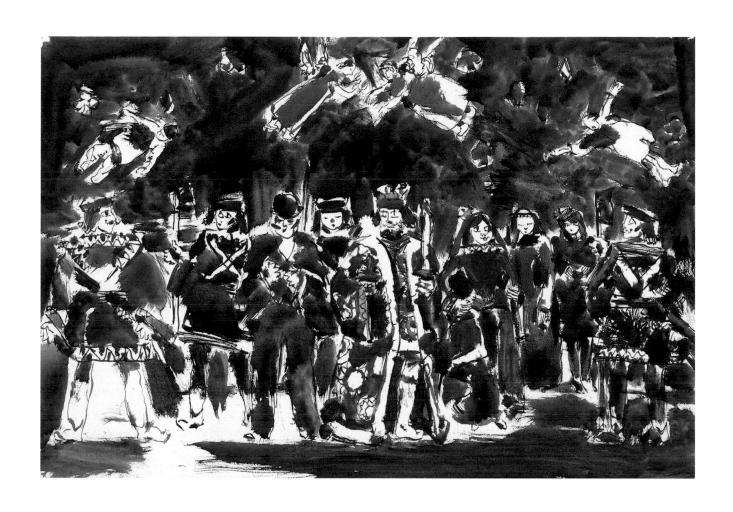

King, Queen, and Jokers III: It's a Democratic Age 1941

Watercolour on paper; 54.6 x 75.6. Milne Family Collection.

The price Milne had to pay to stick to his art was not inconsiderable. His income was under $1,000 a year and stayed there through 1940 and 1941; it then hovered at about $1,200 or $1,300 for the next several years. Regular exhibitions at the Picture Loan Society, and Duncan's conscientious support (notwithstanding his procrastinations) were instrumental in keeping Milne solvent if not rich. At least he was able to devote his time to painting.

Pastimes included gardening in summer, a fall camping trip, and skiing in winter. In 1945, in response to some Canadian government initiative, Milne designed a series of flags – presciently using the red maple leaf as the chief symbol. Milne also wrote a number of brief essays about his work at this time, with an eye for possible publication. In 1947, now nearing sixty-five, he wrote two hundred (typed) pages of an autobiography, which significantly omitted sections of the late 1920s (Big Moose Lake and Lake Placid) and the early 1930s (Temagami, Weston and Palgrave). Otherwise, family life was filled with the routines of work, reading and keeping house. Kathleen kept a diary of Milne's work, each day jotting down the painting he was working on and adding any comments he might make on his success or failure, or on his intentions for the next day.

The two most striking characteristics of the watercolours of the 1940s and early 1950s are the full-blown emergence of the fantasy pictures, or "subject" pictures, as Milne referred to them, and the return of a voluptuous spectrum of colours. The fantasies had their origin in the children's paintings Milne had been inspired by in 1937. He returned to the idea in 1941, when he was biding his time in Toronto's Central Reference Library, awaiting word on the birth of David Junior. He made sketches from two books: one on snowflakes and the other on the history of playing cards. The playing cards shortly afterward transformed themselves into a long-running series of which *King, Queen and Jokers III* (page 55) is but one. These content-oriented works were a clear aberration for the canon of modernist art to which Milne had been for so long an adherent, and it is difficult to justify or explain this drastic shift in his thinking. These two lighthearted subjects were joined shortly by paintings based on biblical stories: *Noah and the Ark*, *The Saint* (see *The Saint II*, page 56), *The Day of Judgement*, *The Resurrection*, *Supper at Bethany*, *Return from the Voyage (Jonah)*, *Fruit of the Tree (Adam and Eve)* and *The Ascension*, a series that stretched to more than thirty versions over three years (see *Ascension XV*, page 57).

The change in Milne's palette from the austere to the voluptuous shows itself in such paintings as *The Green Vase* (page 61) and *Glass Candlestick* (page 61), but it is also evident in the fall ritual of burning leaves – *Rites of Autumn II* (page 60).

In the fall of 1947 Milne went by train to Baptiste Lake, a large lake just west of the town of Bancroft and near the southeast border of Algonquin Park, to look for a new place, perhaps one where he could live alone for part of the year to concentrate on his painting. Uxbridge had lost its inspiration for him, and he was restless. He camped near a tiny stream on a point near a lot he subsequently bought from the government for ten dollars. From there he could see islands, high hills, and evidence of abundant wildlife. His painting that fall was again vibrant and fresh. He returned to Uxbridge after a month.

Nearly all his paintings in early 1948 and thereafter were of Baptiste Lake. (The others were of Toronto, or were fantasies – or "subject" paintings.) In the spring he returned to build a log cabin on his lot, one rather grander than his shack at Six Mile Lake. Indeed, it was almost palatial at 4.9 x 6.7 m (16 x 22 feet).

Milne was sixty-six when he started his last construction project in 1948, and he almost finished it over the summer, building the foundations; laying sixty-one large, peeled logs by himself; setting the windows and door sills; building the chimney; and carving into the hillside outside the front door space for a little concrete pantry, whose wooden door still fits perfectly. In February 1949, having done no painting for nearly a year, Milne returned to his still-unfinished cabin, which thereafter was the only place he painted.

During these last years, Milne was worried about money, since his income was under a thousand dollars a year until 1941, and had been around $1,300 ever since. He worried about providing some support for Patsy and for his new family, and he worried about his health, which was beginning to deteriorate. Duncan, who provided the screen through which all Milne's business and legal affairs were handled, was able to increase his income to $2,500 in 1951, and to $3,500 in the last two years of his life. Although this somewhat eased his financial anxiety, worries about his health began to intrude. In 1950 Milne complained of stomach troubles, and in 1951 he was operated on at Western Hospital in Toronto for cancer of the lower intestine.

The country that Milne explored around Baptiste Lake provided him with many new subjects, inspiring works such as a series of paintings of Camp Makwan. Right at home he found handy subjects. He did a lot of pencil sketching during these years, and most of his paintings were based on these sketches instead of being done outside on the spot. He worked much less now – only in the afternoons, not the mornings – but still managed to dredge up enough energy to complete some remarkable paintings.

Although he worked again by doing many versions of a subject, there was one common aspect to these last paintings. Milne would prepare carefully, map out in his mind the sequence of work, charge his various brushes with the exact amount of pigment and then, in the manner of the Zen masters, would paint the work in a few minutes.

Milne was gripped in his last years by the compulsion to concentrate on his fantasy pictures. He did a series based on Paracutin, the Mexican volcano that emerged in 1943 and erupted in 1952, and another that set Adam and Eve in a barren northern paradise. He returned, at last, to *Tempter with Cosmetics V* (page 8), an amusing riff on angels acquiring high-heeled shoes, lipstick and rouge from an itinerant salesman. This was the picture left on his easel after a vicious stroke on November 14, 1952, ended his ability to paint. He died in the hospital in Bancroft on December 26, 1953, after a year of suffering other strokes and trying to recuperate. He was buried two days later in Mount Pleasant Cemetery in Toronto (section 43, lot 488). His grave is unmarked.

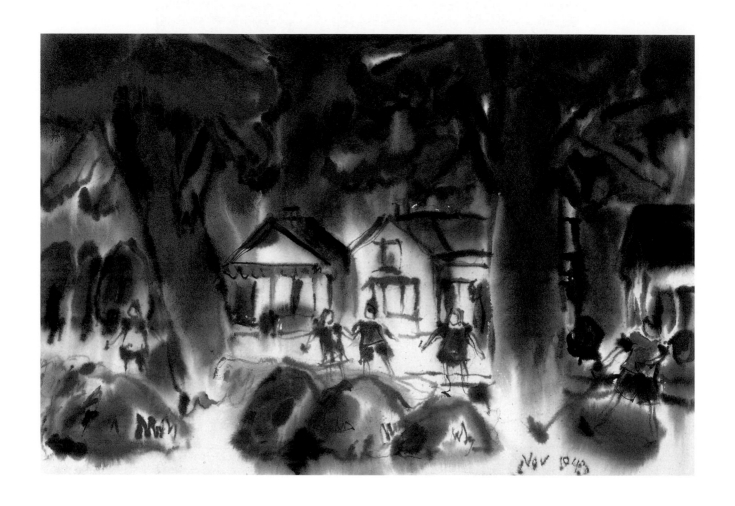

Rites of Autumn II 1943

Watercolour on paper; 36.2 x54.0 cm. Private Collection.

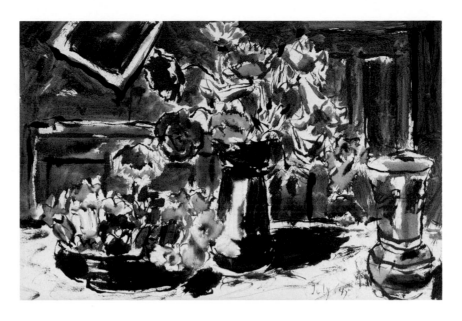

The Green Vase 1947

Watercolour on paper; 36.2 x 54.3 cm. Private Collection.

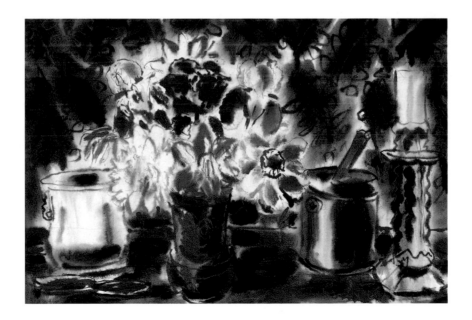

Glass Candlestick 1946

Watercolour on paper; 37.2 x 54.9 cm. Private Collection.

Epilogue

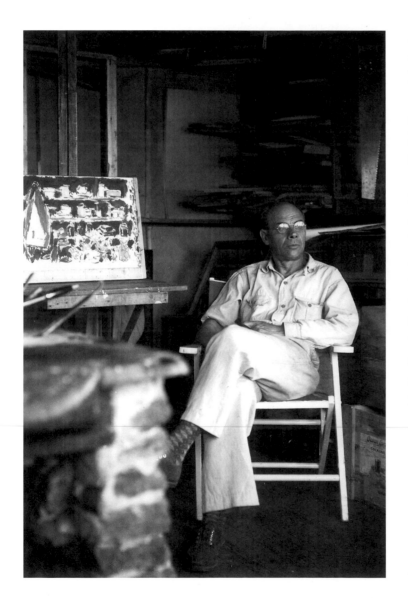

After David Milne died, the National Gallery of Canada organized (1955–56) a full retrospective of his work. Hart House in Toronto held another in 1962. Another retrospective was organized in 1967 and yet another (a major one) in 1991. The National Film Board made a film on Milne in 1962; another, much more detailed and reliable one, *A Path of His Own*, was shot in 1979 by Paul Caulfield. A comprehensive biography, *Painting Place: The Life and Work of David Milne*, was published by the University of Toronto Press in 1996, followed by the two-volume *David B. Milne: Catalogue Raisonné of the Paintings* (1998) and then a CD-ROM of all the works in colour (1999). The major exhibition of Milne's watercolours in 2005 should make his achievement better known in two countries that had a profound influence on the artist. At the time of writing, it is scheduled to open at the British Museum, move to the Metropolitan Museum of Art in New York and conclude at the Art Gallery of Ontario in Toronto.

David Milne, Six Mile Lake, 1938